FOUR STEPS TOWARD MODERN ART

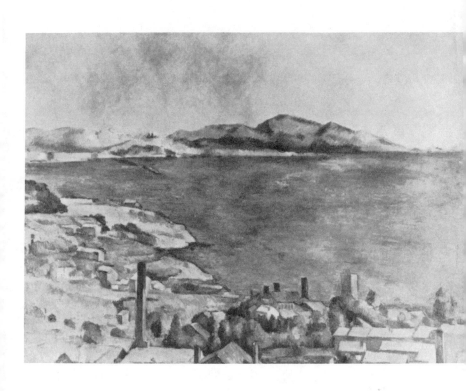

CÉZANNE: *L'Estaque*

FOUR STEPS TOWARD MODERN ART

GIORGIONE

CARAVAGGIO

MANET

CÉZANNE

by *Lionello Venturi*

GREENWOOD PRESS, PUBLISHERS
WESTPORT, CONNECTICUT

Library of Congress Cataloging in Publication Data

Venturi, Lionello, 1885–1961.
 Four steps toward modern art.

 Reprint. Originally published: New York : Columbia
University Press, 1956. (Bampton lectures in America ;
no. 8)
 1. Giorgione, 1477–1511. 2. Caravaggio,
Michelangelo Merisi da, 1573–1610. 3. Manet, Edouard,
1832–1883. 4. Cézanne, Paul, 1839–1906. 5. Painters––
Influence. I. Title.
ND35.V38 1985 759 84–27918
ISBN 0–313–24800–1 (lib. bdg.)

The lectures in this book were originally delivered at
Columbia University in 1955, as the eighth in the series
known as The Bampton Lectures in America

Reprinted with the permission of Columbia University Press

Reprinted in 1985 by Greenwood Press
A division of Congressional Information Service, Inc.
88 Post Road West, Westport, Connecticut 06881

Printed in the United States of America

10 9 8 7 6 5 4 3 2 1

CONTENTS

PLATES

GIORGIONE

A FEW WORDS are necessary to explain the general title of these lectures: *Four Steps toward Modern Art*. Everybody knows that Giorgione is a famous artist. But why is his work considered a step toward modern art? In order to understand this, it is well to recall that great painters, besides having inherent value as artists, are extremely significant for later artistic trends, even of a distant future. It is true that a work of art is a closed unity, where all elements are tied together with their companions and rooted in the same individual creation. If you isolate one or more elements, these lose the artistic character which is given them by the whole. But it is also true that younger generations carry away from the work of their masters some elements which acquire a cultural value as soon as they lose their original artistic value. Of course, when these elements are incorporated into a new work of art, they become again artistic, but in their new context they take on a completely different meaning. The interaction of the created and of the cultural elements is what gives a work of art its historical character. Indeed, a creation may appear eternal—that is, beyond history—but no creation exists without a cultural basis, and it is culture which lets us distinguish a Renaissance from a Gothic work of art.

To be sure, all great artists are important both for their artistic value and for their influence on the later development of art. But I think that the four artists I have chosen for these lectures had so great a following that they must be counted among the most successful leaders in taste. It is enough to recall that Giorgione initiated Venetian painting of the sixteenth century; that Caravaggio was the founder of the luministic trends of the seventeenth century; that Manet was the creator of the aesthetics of impressionism; and that Cézanne has been regarded in the last fifty years as the founder of modern art.

Giorgione was very young when he appeared on the artistic scene about 1500, and he died in 1510. This decade was momentous: Raphael painted in those years many of his masterpieces, Leonardo and Michelangelo created works which were to influence everybody, and Bellini and Botticelli, though old men, were still working. However, the brilliancy of their achievements could not conceal the crisis which was hitting the Italian Renaissance—a political, moral, and religious crisis. The Florentines, who for the whole of the fifteenth century had been the leaders of civilization, felt the crisis more profoundly than other Italians. During the fifteenth century they centered their artistic efforts in the figure of man, who was

considered the center of the universe. They also created a perspective of space around man, in order that he might appear in his nobility and magnitude. Finally, through the study of anatomy, they formed the figure with complete understanding of its internal construction and then empowered it with all movements, expressing through physical action the movements of the soul.

All this resulted in the discovery of man, of his place in the universe, of his power and action. The conquest of reality seemed complete. But at the end of the century the faith in man's ability to overcome reality gave way to a certain skepticism; the evasion of reality caused the detachment of art from human life and from nature. A certain idealization followed, which was called classic and which was art for art's sake. All the artistic life around Pope Leo X went on in a rarefied atmosphere. It was possible for a genius like Raphael to paint masterpieces even in such circumstances. But such an evasion could have only evil consequences, for it was not rooted in the spiritual life of the time and thus could not endure. In central Italy mannerism was its result.

At that moment Venice took the leadership. The only way out of the rarefied atmosphere of Raphael's classicism was the return to feeling. Leonardo da Vinci had proposed and

theorized the necessity of the universality of painting, that is, the ability of the painter to represent not only man but also landscapes, rain, and stars. Giorgione conquered through feeling and imagination what Leonardo theorized.

The painter who is considered the master of Giorgione, Giovanni Bellini, assimilated everything the experience of the Florentines of the fifteenth century could give but remained faithful to a serious religious tradition of coloring. Giorgione developed Bellini's tradition in a more human sense. He preserved the religious feeling, but he transferred it from the Christian God to the whole of nature, thus anticipating the conception of pantheism. While profiting from his experience with colors, exploiting their beauty and expressive quality, he modified the tradition by emphasizing the qualities of light and concerned himself with the problems of this new element. Thus he interpreted man as well as nature and combined human figure and landscape.[1] The very day Giorgione painted a landscape with figures, instead of a figure with a landscape background, thus renouncing the painting of a story about man in order to express his love of nature, that very day a new voice was heard which anticipated modern thought and feeling.

Venetian painting of the sixteenth century, from Giorgione on, continued to express religious fervor, but it was no longer that of the Christian medieval tradition, nor that of the Reformation, nor that of paganism, nor that of the Neo-Platonist compromise between paganism and Christianity. Venetian religious feeling was experienced in the face of nature; it was love of nature and forecast the modern religion of nature.

Giorgione's art is no longer a creation of science, it is no longer directed toward stress upon knowledge: its aim is the free flow of the imagination. Its detachment from science is not irrational, for it does not oppose science: it simply ignores it and follows the senses and imagination. The same may be said of its relationship to antiquity. Venetian painters bowed to antiquity, but they were concerned with reality. From the middle of the sixteenth century there were critics who opposed Roman classicism to Venetian realism. Venetian painters did not oppose the classical, they even derived some profit from it, but their colors and lights, their women and trees held more importance for them than did antique statues.

These were new horizons, the horizons of a new realism, broader than that of the Renaissance because no longer limited

to man. Man was no longer abstract from, but immersed in, reality, and nature became humanized, not because it was subdued but because it was adored by man.

This was the end of the Renaissance; it was the beginning of the modern era. And so in the two eventful centuries between 1400 and 1600, Italians not only created the Renaissance but opened the door to the new age.

There are three paintings in which Giorgione expressed the whole of his genius better than anywhere else. They are *The Thunderstorm* (Fig. 1), in the Gallery of Venice; *The Three Philosophers* (Fig. 2), in the Vienna Museum; and *Sleeping Venus* (Fig. 3), in the Dresden Gallery. These works have no precise subject matter, either religious or mythological. The painting of *Venus* is merely a pretext for painting a woman in the nude, and the *Three Philosophers* and the *Thunderstorm* are pretexts for freeing the imagination. Giorgione painted these three works for private citizens, his companions—young Venetian aristocrats who loved good painting and were indifferent to subject matter.

When in 1541–42 Giorgio Vasari [2] visited Venice, he looked at the frescoes by Giorgione in the Fondaco dei Tedeschi and stated with surprise that he could not understand what they represented, that they appeared painted by whim. X-rays

confirm [3] that Giorgione painted without any subject matter
in mind. He began by showing a woman bathing in a river,
then he covered this and substituted for it a standing man
(a soldier). If he had had a subject matter in mind, or if
he had been commissioned to illustrate a subject matter, he
could not have replaced his bathing woman with a standing
soldier. Marcantonio Michiel, the oldest and the most im-
portant source about Giorgione, says that the painting repre-
sents a soldier and a gipsy, thus showing that he did not
see any story illustrated in it. Finally, the substitution of the
soldier for the bathing woman can be explained by the balance
of the scene and by the desire to add a touch of mystery.

The fact that Giorgione changed his mind while painting
the *Three Philosophers* is also revealing.[4] The figure at the
right originally wore an Oriental diadem, the central figure
was a Moor, the left figure wore an Oriental hat: they repre-
sented the Magi. But in the final version this subject matter
no longer appears. As Michiel [5] tells us, they are three philoso-
phers—not individualized as Aristotle or Regiomontanus, as
has been supposed, but philosophers in general. In the Uni-
versity of Padua, young Venetians studied three trends of
philosophy which struggled with one another for preeminence;
that is, the Aristotelianism of scholastic tradition, Averroism

or Arabic philosophy, and the new "science of nature," then at its dawn. It is easy to see that Giorgione wanted to show what was the common knowledge of his time personified in the old Aristotelian figure, in the Oriental Moor, and in the young man who is measuring nature. Thus he transformed the story of the Magi into one of his cultural fancies: a very important step had been taken in the conquest of the autonomy of art.

X-rays show also [6] that originally a Cupid was at the feet of Venus. But the Cupid could not change the meaning of the painting as we see it now, that is, the correspondence between the sleep of the woman and the sleep of nature.

Thus in all three paintings Giorgione emphasized the meaning of the general harmony of human and natural images without narrating any story.

The Three Philosophers and the *Venus* were left incomplete by Giorgione and were finished by two of his followers, Sebastiano del Piombo and Titian. There are other paintings he left unfinished, but not because of his early death. Leonardo da Vinci, too, did not like to finish his works, for example his *Adoration of the Magi* and his *Saint Jerome*; and Michelangelo left works incomplete throughout his life, from the

Saint Matthew to the *Pietà Rondanini.* During the Middle
Ages the perfect finish of a painting was expected of the
artisan's work, but the Renaissance emphasized that a paint-
ing was the work of the mind rather than of the hand. Thus,
when Leonardo or Michelangelo or Giorgione felt that in
their works the intimate meaning of their imagination had
been expressed, they no longer cared for the illusionary repre-
sentation of reality. This indifference toward illusion was a
step toward the autonomy of art.

In these three paintings—*The Thunderstorm; The Three
Philosophers; Sleeping Venus*—Giorgione attached great im-
portance to landscape. There is continuous interaction be-
tween human figure and surrounding space, filled by atmos-
phere, trees, and earth. As a result, man and his actions were
no longer the protagonists in painting, but the artist embraced
the whole of nature in his vision in order to reveal his own
feeling. For the first time, in *The Thunderstorm*, we have a
landscape with figures instead of figures with a landscape.

The Florentines detached the figure of man from the sur-
rounding space: Giorgione wanted to immerse it in atmos-
phere. In order to do so he wanted an open rather than a
closed form. To realize an open form was the most difficult
step, because he could not completely renounce the beauty

of a contour. However, his last works show a pictorial form which was to be developed in the following three centuries and whose origin must be traced to Giorgione.

Leonardo da Vinci theorized an open pictorial form, but he could not realize it in his paintings because of his preference for plastic form and sfumato. But Giorgione had been rooted in a tradition of coloring which operated in his mind even before he used his tints. X-rays of *The Three Philosophers* show that the monochrome drawings were even more pictorial than the painted figures. Vasari [7] saw this fact very well. He wrote that Giorgione painted directly from nature, imitating it with delicate colors and strong contrasts of light and shade, without any previous drawing, because he believed that true painting and true design could be better realized through colors on the canvas than through drawings on paper.

Open form, contemplation of the universe, indifference toward finish, chromatic conception of the drawing—these were the basic impulses of Giorgione's imagination. He expressed a state of mind rather than precise passions. His sensuality was liberated from the knowledge of sin and was at the same time restrained by a panic ecstasy in the face of nature. This is the origin of Giorgione's lyricism, of the enchantment brought by his paintings to all those who feel the

expression of dreams, of the caress of light on man, and of things awakening at dawn or going to sleep at dusk—to all those who find concealed in their innermost nature the romantic desire for what is unseen, unknown, and out of range of human possibilities.

By looking at the reproductions of some paintings by Giorgione, it is easy to understand how Giorgione realized the principles we have summarized.

The Thunderstorm (Venice Gallery). Marcantonio Michiel,[8] who first described the paintings of Giorgione, saw this work in 1530 in the house of Gabriele Vendramin, for whom the artist had painted the picture about twenty-five years earlier. He described it as "a landscape with thunderstorm, a gipsy, and a soldier." Thus not a historic or literary theme, but a landscape with figures. These are included in the vision and the feeling of the landscape.

Since they perform no action, the figures are not the most important elements, and they leave the center of the picture open toward the background while the background assumes the role of the protagonist of the scene. Here is the thunderstorm. Menacing clouds are gathering, a streak of lightning rips them asunder. The sun is setting, and the light falls on

the houses along a canal. The canal is dark, as is the sky; together, they frame the brilliant, almost spotted light on the houses. An unnatural light, a light which is precious and smiling but at the same time uncertain and suggestive of its own passing.

The foreground is separated from the menacing storm and the baleful light by an ancient ruin and by a group of trees. Both form a kind of coulisse to conceal the gipsy and the soldier. Here is a kind of ideal grotto, where a soldier is standing and a half-nude woman is nursing her child. The figures are not related to each other—no movement, no action. They are living, gazing into space, contemplating, dreaming— in short, participating in the life of nature. They have the same calm as has the water flowing over rocks and through meadows. Wordsworth defined a lyric poem as emotion recollected in tranquillity. This painting is a piece of such lyric poetry, dedicated to the approaching sunset behind the thunderstorm and to the refuge which men and things find in a corner of the countryside withdrawn from the active world.

The Three Philosophers (Vienna Museum). This painting is mentioned by Michiel [9] as three philosophers in a landscape "with a stone marvelously reproduced." This is interesting, for it is the only aesthetic appreciation made by Michiel and

offers the suggestion that Giorgione's contemporaries appreciated his painting because of his approach to nature.

At the right Giorgione places the personification of Aristotelian philosophy; in the middle, Averroistic philosophy; at the left, the new Paduan philosophy of nature. The painting is an imaginary participation in that dawning hope found in both the art and the thought of the time, the hope to be able to look at nature unrestrained by ancient and medieval rules. This participation is the dream of an artist. The time chosen is dawn. Again human life is limited to a corner of the countryside almost enclosed by rocks and trees, and in this refuge a young man,[10] alone, mentally detached from the men of the past, is lovingly contemplating nature in spite of the compasses he holds. Calmness, a sense of refuge, suspension of activity in dream—this is the stamp of Giorgione's personality, even though he participated in the philosophical life of his time.

Sleeping Venus (Dresden Gallery). The figure is that of Venus—but is the painting a representation of the goddess of love? Giorgione had painted a Cupid standing at the feet of the nude, but later the Cupid was covered up. Giorgione's invention transforms the mythological motif into a contemplation of nature. Again there is the sky at sunset; nature is

about to sleep, and so the woman sleeps. Her nudity makes her a part of nature, her lines have the same rhythm as the lines of the hills, the same dream envelops her and the landscape. Her beauty accents the beauty of nature at the moment of spreading silence. To understand the dreamy accent of Giorgione, compare this with a Venus by Titian (Fig. 18). The pose is still that of Giorgione, but the conception is a new one. Instead of Giorgione's dream of the mythological goddess, Titian has imagined a rich and beautiful lady of the court, lying on her bed in her room as she waits for her maid to bring in her gown. The dream is gone, everything is reduced to reality.

Pastoral Music (Fig. 4; Paris, Louvre). Two young men are immersed in musical contemplation. They have stopped playing; they look at each other; music is woven into their dream. A nude woman is looking at them and waiting for the music to start again; another with slow movement is drawing water from a well. The group is shown in a corner of a broad landscape of hills, valley, and woods, with a flaming horizon and thick sunset clouds. Here also is contemplation, suspension, life without action, music and dreams.

Two of Giorgione's outstanding characteristics are sensuousness and musicality. A sensuous approach to nature is ap-

parent in his works; it is expressed not only in his nudes but also in his trees, rocks, and sunset horizons. But this sensuousness does not stop at the image, it envelops the entire harmony of nature. It becomes immaterial, indeterminate, and goes beyond any image or object. It spreads to the atmosphere and becomes transformed into a memory of emotion, with a hint of melancholy. This is the musical level of art, always concrete in sensation yet never realizing the sensation with the precision of an image or a word. And you can further see that Giorgione's discovery of a nature which includes human figures as things of nature was imbued with a dream quality. It was a dream of things sensuously experienced; but, just as in music, as the dream developed, the sensuous experience was already gone, and contemplation of it took its place —the rather melancholy recollection of a past interlude.

Similar in mood is *The Concert* (Pitti Gallery, Florence; not reproduced here). There is much dispute as to whether this work is by Titian or by Giorgione. If we believe it to be by Giorgione, it is because the expression in the protagonist has more the power of dream than of action. The artist's attention was concentrated on the protagonist, dressed in black so that the face, suffering the passion of music, and the hands, nervous as piano strings, might receive full emphasis, resulting

in a great intensity of emotion, an emotion dominated by dream.

The paintings examined up to now have motifs invented by Giorgione. They show a complete break with tradition both in their conception and their execution. They belong to the mature period of the artist, in spite of his young age, and they show his style fully developed. But we know some earlier works of his, and these show his timid and explorative attempts before he reached his perfection. They do not show a break with the tradition but a gradual liberation from it.

Madonna and Saints (Fig. 5; Cathedral of Castelfranco). This painting, which hangs in the cathedral of Giorgione's native town, accepts from the models of Giovanni Bellini the placement of the throne in open country and the architectural construction of the group, but these are modified. The throne is very high, and the absence of a canopy leaves the whole composition open to the sky. Moreover, figures and landscape are separated by a red velvet drapery. It is a shy and delicate composition, the gestures of the figures are very reserved, the lack of plasticity gives the figures the character of dreamlike phantoms rather than of real beings. The religious ideal of Giovanni Bellini, so profound and rooted in

an old tradition, has disappeared in order to open the gate to a worldly though nostalgic fancy.

The *Adoration of the Shepherds* (National Gallery, Washington) is more indicative of Giorgione's style than is the *Madonna* of Castelfranco. Here the scene is limited to the foreground in front of a grotto where the Madonna, Saint Joseph, and two shepherds are adoring the Child. This scene is placed in a corner, separated from nature, but it is the landscape developed at the left which accents the entire picture. Life runs through the lights and shadows, rivers and trees, towers and hills, until finally the sunset at the horizon gives calm and quiet. This is what Giorgione contemplated; this is what he adored.

Judith (Hermitage, Leningrad) shows an elegant young girl who seems too delicate and timid for a murderess. The pictorial values can be seen in the light of the sword and in the detached head, its features convulsed by violent death. But in the figure of Judith the line is still important and very similar to that which Raphael used at the same time (about 1505). It is the presentation of a figure rather than the representation of a drama which in this picture announces the future development of the art of Giorgione.

Self-Portrait (Fig. 6; Braunschweig Museum). It is interest-

ing to note that Giorgione, whose art was never dramatic, represented himself as a *David with the Head of Goliath.* Perhaps he wanted to stress the novelty of his work in comparison with that of the past. The picture was later cut, and only the head of David is preserved. It is a beautiful head, with the dreaming expression typical of Giorgione, but with an intensity of life which is exceptional and reaches the vibration of real suffering.

In less than ten years of activity Giorgione painted some of the greatest masterpieces of Italian art and liberated Venetian painting from the limits, however broad and glorious, of the humanistic art of Florence. A conquest of freedom is always a step forward in the civilization of mankind.

CARAVAGGIO

THE FAME of Caravaggio has spread very much in recent years, so that the presence of his art is deeply felt in the art of today.[1] Why? He has always been considered a champion of realism, and since the beginning of our century the trend in art has been more or less abstract.

Here it is well to recall that every work of art is at the same time concrete and abstract. Realists emphasize the representation of concrete things, abstract painters emphasize the representation of their style. So one might ask whether Caravaggio is so realistic as he is traditionally believed to be, or whether his volumes, his geometric lines inherited from the mannerists, the effects of light and shade which dominate his compositions are not responsible for the interest in Caravaggio's art shown by many painters today.

No doubt, contemporaries fought Caravaggio, or patronized him, because of his realism. But in the concept of realism then was included an idea of class. Patrons of chapels in the churches did not want to pay for pictures in which saints were represented as peasants, pilgrims were dirty, and the Madonna was a poor dead woman. They wanted to recognize themselves in the saints of Paradise and felt a challenge in the peasant

apostles Caravaggio painted. And so they declared that his art was vulgar.

This social character of realism was at the origin of the polemics against Gustave Courbet, a distant heir of Caravaggio, who painted in France during the Second Empire. His art was considered not only vulgar but also aggressively hostile to established society.

At the beginning of our century, interest in Caravaggio began to grow. The writings of Kallab, Longhi, and myself [2] have clarified the events of his life and his production. But the interpretation of his style came first not from an art historian but from a great novelist, Aldous Huxley, who in his earliest novel, *Crome Yellow* (1921),[3] explains from a cubist point of view the simplified, formalized nature represented by Caravaggio. The Milan exhibition of Caravaggio in 1951 was the manifestation of a struggle against abstract art. All those who dream of reducing art to photography, all the followers of Soviet realism, were triumphant: they believed they had found their banner in Caravaggio. Of course, true artists followed their own way, and true critics laughed. They felt that the message of Caravaggio did not consist in his ability, great as it was, to imitate natural things but in a style which impressed on the representation of things an artistic

value, an eternal shape. Besides the volumes, the geometric lines, the effects of light and shade, modern critics recognize that the source of his creation is a struggle for truth, parallel to that of the great men who lived in or about the same age— Giordano Bruno and Campanella, Galileo Galilei, Shakespeare, Velázquez, and Rembrandt. In one way or another all of them were the champions of truth, the founders of that civilization which ended in the French Revolution. As far as Caravaggio is concerned, his struggle was against the accepted prejudices of the mannerists and the classicists and against the arrogance of an aristocratic Church.

Mannerism was a kind of abstract art created by people who were dissatisfied with the so-called perfection of classic art and tormented by the religious and political uncertainty of the sixteenth century. The young Caravaggio was educated by mannerists, and he used their forms, but for some years he was uncertain as to which path to follow. Even then, however, his abstract forms had such an intensity of feeling, such an evidence of truth, that they were considered the reality itself.

Caravaggio's fight against the mannerists consisted therefore not in the invention of new principles but in the serious and conscientious performance of what they were doing super-

ficially, repeating dead formulas and indifferent to the content
of their expressions. The reaction against mannerism was
thus the work of a young Lombard in Rome.

Classicism was at its dawn when Caravaggio was painting.
Annibale Carracci went to Rome in 1596, and the impression
he received from Roman antiquities forced him to modify his
Bolognese style in the direction of classical dignity. It is well-
known how great was the success of classicism thanks to the
Carracci school, Poussin, Mengs, Canova, and David. Cara-
vaggio, who had arrived in Rome two or three years before
Carracci, did not turn his back on his North Italian education
in order to become a classicist. A legend told of him illustrates
this fact very vividly. Once, when shown Greek statues for
study, he made no reply but pointed to a crowd of people to
show that nature had provided him with plenty of models.

The years 1595–1610 in Rome were an extraordinarily event-
ful period: from it emerged the two most important trends in
art for two centuries and a half—realism and classicism.
What is even more extraordinary is that Caravaggio started in
Rome that artistic struggle against the arrogance of an aristo-
cratic Church, which the Counter Reformation had promoted.
Naturally, such a struggle could not last. Ten years after
Caravaggio's death his influence had almost vanished in

Rome, and classicism triumphed. The role of continuing and developing Caravaggio's social struggle fell on the great masters of the Dutch school and, at a later age, of the French school.

We can understand why in the present day people are interested in Caravaggio. Besides volumes, geometric lines, and effects of light and shade, Caravaggio brought into art a new longing for truth which gave a dramatic aspect to his life as well as to his art.

The artists of the fifteenth century aimed at realism in the sense that they conquered new ways to represent the external world. Their conquest was a pretext for the development of their sense of beauty, of their expression of energy, and finally, of their ecstatic contemplation. But for them the only struggle was within themselves. In the sixteenth century both classicism and mannerism departed from realism, and by the end of the century the general opinion was that the forms of the mannerists had become too conventional. A reform was desired which would create a new respect for reality without excluding the classical ideal. Annibale Carracci answered the desire for reform, reaching a wise compromise between realism and idealism. Unfortunately, compromise in art almost always opens the door to hypocrisy. And since hypocrisy was

particularly flourishing during the seventeenth century, Carracci's classicism achieved a triumphant success.

Caravaggio, too, felt the necessity of reform against mannerism, but he was aware of the hypocrisy inherent in classicism. To choose only the ideal in nature appeared to him a blasphemy. To him, everything in nature was worthy of representation; the choice must be made among the pictorial means, along ways leading to a personal style. At a time when only historical painting was appreciated, Caravaggio proclaimed that an apple was as good as a Madonna in order to realize a painting. Thus he fought not only against the mannerists but against the classicists also. The essential difference between his realism and that of the painters of the fifteenth century consisted in his polemics, in his pushing his ideas to the extreme. This allowed Caravaggio to emphasize his longing for truth regardless of consequences—to become, in fact, a symbol of truth in art.

The reaction against him came from two quarters. There were first of all the painters who were using their abilities to please their clients, to make women look like goddesses and God like a king; they felt in Caravaggio the condemnation of their art, and his art was for them very vulgar. Another reaction came directly from the priests, who understood the

danger of placing on the altars images of peasants instead of images of kings and princes. This double reaction was responsible for the troubles which plagued Caravaggio throughout his life.

Michelangelo Merisi, the son of an architect, was called Caravaggio after a little town near Bergamo in Lombardy, where he was born in 1573. In 1584 he went to Milan to the school of a Bergamo painter, Simone Peterzano, who followed Titian in a manneristic way. Around 1592–93 he reached Rome, where his life was fraught with hardship. He was exploited by a member of the clergy, starved to the point of illness, and was treated in a hospital. After that, he went to work for a popular mannerist painter of the day, the Cavaliere d'Arpino, for whom he painted flowers; but this subordination was intolerable. Finally Caravaggio found a patron who commissioned him with the paintings in the Church of San Luigi dei Francesi, and these works caused a tremendous sensation in the artistic world of Rome. His admirers were many, but so were his foes. Twice his paintings, called plebeian and unworthy of the House of God, were refused a place on the altars. The difficulties he encountered, the insults hurled upon him, and the traps set by his enemies embittered him

and eventually unbalanced his mind. His counterattack was not only a series of masterpieces: he also resorted to slander, violence, and eventually murder. Between 1603 and 1605, he was prosecuted four times, but at that time the law was very weak and a patron could easily obtain the release of a prisoner. In 1605 Caravaggio wounded a notary in an argument over women and fled to Genoa; but a month later he returned to Rome to sign a retraction of the charges against the wounded man and a petition for his pardon. In 1606 he was involved in a much more serious quarrel. A certain Ranuccio of Terni was attacked by Caravaggio and a Captain Antonio of Bologna. Captain Antonio and Ranuccio were killed, and Caravaggio sustained a serious head wound. He found a hiding place not far from Rome while the Duke of Modena and other patrons endeavored to obtain his readmittance into Rome. But this time his offense was too grave, and he had to flee to Naples and then to Malta, where he secured a favorable reception by painting the portrait of Alof de Wignacourt. But his violent temperament was the eventual cause of his ruin. He insulted a Maltese Knight, was imprisoned, and escaped to Sicily and thence to Naples. There he was wounded in an encounter with his pursuers. His flight continued by sea to Port'Ercole in Tuscany, where he was

imprisoned for two days on an erroneous charge. Tired, wounded, and discouraged, he died of a fever on July 18, 1610.

It is a tragic paradox that Caravaggio the exile, the lawless citizen, the murderer, should have been a profoundly moral and religious painter. Refusing to conform to the official religious way of life, he became a rebel in order to deepen the religious feeling in his paintings for the churches and to remain faithful to the spirit of the Gospels.

Before discussing Caravaggio's paintings, it is instructive to examine his system of painting such as the X-ray camera reveals it to us.[4]

No drawing by Caravaggio is known to exist, and there is good reason to believe that he painted without preliminary drawings. This seems to have been confirmed by X-ray photographs of *The Martyrdom of Saint Matthew* (Fig. 7) and *The Calling of Saint Matthew*.

The problem of painting with or without previous drawing had been discussed during the Renaissance by Giorgio Vasari. The Florentine and Roman masters had realized their composition by first drawing on paper and later transposing the drawing to the painting; but Giorgione painted without previous drawing, and Vasari thought it was a mistake. The man-

nerists were draughtsmen rather than painters. Caravaggio, on the contrary, wanted to paint directly what he imagined. Indeed, the X-ray photographs of the large canvas of *The Martyrdom of Saint Matthew* (Figs. 8, 9, 10) show not only that Caravaggio improvised his composition on the canvas but also that he changed it three times.

The first version was of a symbolic character. The event was calmly narrated, even ancient architecture was represented in order to reconstruct the ambiance of the martyrdom. It was a composition which still belonged to the Renaissance tradition. The second attempt is so confused that we can only assume that it was a little more dynamic and dramatic. The third rendering, that which we see in the painting, is a fully dramatic composition. Action is substituted for contemplation, nothing remains of the reconstruction of the ambiance, and the dark space is filled by images in the third dimension as well as in the surface. In other words, from the first to the third version, Caravaggio abandoned the Renaissance tradition and began the baroque one.

It should be realized that the purpose is here homogeneous with the means. A baroque effect is tied to an improvised manner of painting, light and shade play through the three dimensions, and drama prevails rather than contemplation,

while the importance of expression becomes greater than the representation of the body.

Similarly, the X-ray photographs of *The Calling of Saint Matthew* show that the spiritual appearance of Christ and his magic power are the result of a correction made in a second version.

A few examples from Caravaggio's work will illustrate and make intelligible the evolution of his imagination.

The Basket of Fruit (Fig. 11; Milan, Ambrosiana Gallery) is not Caravaggio's earliest known work, but it presents an easy approach to his art. Think of all the crowded religious and historical scenes painted in Italy during the sixteenth century, in which sacred and heroic images expressed the classic ideal and contained the quintessence of knowledge, from religion to history, from perspective to anatomy. A new trend, the trend of modern painting began with a simple basket of fruit. To avoid a complicated subject; to express the unsophisticated contemplation of a simple basket of fruit, showing the various aspects of a leaf, the roundness of an apple, the highlights of a grape, all related in a subdued tone to the light background; to prove that a simple motif like this could be the subject matter of a painting—all this required

superhuman humility toward nature. And this is an outstand-
ing achievement not only artistically but also morally. Once
and for all it freed painting from the prejudice of genre and
subject matter and placed the still life on a pedestal. If
Cézanne succeeded in finding his style by painting apples,
it was because Caravaggio, three centuries earlier, had pointed
the way.

One of Caravaggio's earliest known paintings is the *Bacchus*
in the Uffizi Gallery, Florence. Think of all the statues of
Bacchus from the ancients to Michelangelo, how they show
that superb joy of living inherent in this pagan god. Here in-
stead is a masqueraded boy, fat and clumsy, with a sheet for a
classic mantle, who seems to be only a pretext for portraying
a still life. It should be noted that the drawing still shows
a good deal of mannerism and that the nude is an academic
achievement. In other words, Caravaggio is not quite emanci-
pated from his manneristic training. His realistic conception,
which is an insult to the classic god of wine, anticipated the
creation of the new realistic form.

Classic mythology and Christian legends are used by Cara-
vaggio to express moments of everyday life—witness his
Magdalen (Fig. 12; Rome, Doria Gallery). There is no hero-
ism. In contrast to the handsome clothing and jewels, foreign

to her normal life, a poor girl is seated against a bare wall, with a ray of light from above, as though in prison. She is meditative, sorrowful, resignedly acquiescent. Her form is pleasing and commonplace. Renaissance painters identified the repentant Magdalen with Martha's sister Mary and made her into a Christian Venus—an image far removed from the reality which Caravaggio saw with moral acuteness. Also, note the artistic conception anticipating form, which is still manneristic.

The Flight to Egypt, also in the Doria Gallery, is a very complex painting. Here we find an angel who is the most manneristic achievement of Caravaggio, very beautiful indeed, linear and ideal. Very close to it we see a Saint Joseph and the head of an ass painted in a realistic and pictorial way. Finally, at the right, we see the poetical sleep of both Mother and Child in a fine landscape. This painting is a summary of the trends and the dreams of Caravaggio's early youth.

Caravaggio found it necessary to disrupt manneristic form and to destroy traditional form in order to create a new one. His *Medusa,* a circular painting in the Uffizi Gallery, Florence, offered him a good opportunity to do this. His aim was to paint ugliness and horror. He therefore found in the theme itself the suggestion of deformation and destruction of tra-

ditional manneristic beauty. Strong shadows and distorted
lines were the means he used—but look at the mouth and see
how Caravaggio found a new geometric order in the dis-
tortion.

The *Triumphant Cupid*, in the Berlin Gallery, is a better
example of the new form Caravaggio originated to express
his realistic ideal. He aimed at a parallel of traditional beauty.
Here is a young man—a beautiful young man; but his beauty
is unlike classic or Renaissance beauty. In the plasticity as
well as in the pose there is an excess, a forcefulness, an effort
which lacks classic serenity. Cupid is laughing, not smiling.
An effort, a polemic permeates the expression. It is a con-
quest, not a possession. And the secret of the struggle underly-
ing the solid form is the contrast of light and shade. Tradi-
tionally it has been said that Caravaggio achieved his realism
by substituting nocturnal light for daylight. The fact is that
he used an imaginary light, striking here, disappearing there,
according to the flight of his imagination rather than to phys-
ical reality. Thus this painting appears more dashing and
striking than his earlier ones.

The *Saint John the Baptist* in the Doria Gallery, Rome,
is conceived as a naked young man, not unlike Cupid, em-

bracing his lamb. The contrast of light and shade is more varied, free, the plasticity less pronounced than in the *Cupid*. The coherence of the image is greater, as is its artistic value.

When after 1597 Caravaggio was commissioned to execute some paintings in the Church of San Luigi dei Francesi, Rome, he prepared a picture representing *Saint Matthew Inspired by His Angel*, which he intended to place on an altar. It was rejected by the church and was in the Berlin Museum until destroyed in 1945. What was the reason for refusing this great masterpiece? It seems that Saint Matthew was portrayed with dirty feet, and this was considered unsuitable for a church. Caravaggio concentrated his realism in Saint Matthew, representing him as a hard-working man, a man who could scarcely write and who could accomplish his task only because he was guided by an ideal. And the ideal is personified in the angel, whose white wings and delicate forms surround the Evangelist. To imagine Saint Matthew this way implied interpretation of the Gospel as well as of the reality of everyday life. The angel, because of the contrast, is a true image of the ideal, the angel of dreams, decidedly more ideal than a manneristic angel. The contrast between the expressions is somewhat dramatic and is realized not only by the contrast of light and shade

but also by the counter-direction of the two bodies, which complement each other in an ideal circle.

On a lateral wall of the same chapel Caravaggio represented the *Calling of Saint Matthew*. In a dark room a strong but limited light enters, not from the window, but from the upper right corner, like a supernatural light. Christ appears on the right and points to Saint Matthew; represented as a bearded man, seated and playing cards with indifferent young companions, Matthew is suddenly struck by the light of Our Lord. The card players and their elaborate costumes make this a genre scene, but it is also a serious religious scene because of the light and the concentration of expression in the illuminated hand of Christ. Light becomes the protagonist. It absorbs plastic form. The slightest remainder of manneristic form disappears.

The Conversion of Saint Paul (Fig. 13; Rome, Church of Santa Maria del Popolo) is another of Caravaggio's masterpieces. The figure of the saint lying on the ground is foreshortened so that it can penetrate the dark atmosphere. In that darkness, an overpowering light strikes the bodies of Saint Paul and the horse. Paul's arms continue the line of the horse so as to form a complete circle, diagonal to the plane of the picture.

And now reflect on the problem of realism. There are many painters who have portrayed Paul falling on the road to Damascus by showing God the Father appearing in the sky, the horse frightened and rearing. This sort of thing did not appeal to Caravaggio. His realism was neither illustrative nor narrative. Because he wanted to represent the volume of bodies, he had to avoid too much movement. Light, imaginary light, was sufficient to create the drama intensified by the geometric contour.

The Entombment (Vatican Gallery) has the same synthesis of dramatic affect because the group has unity, with one exception: the melodramatic gesture of the holy woman at the right raising her arms in despair—an unfortunate concession to representation. The rest of the group seem to fall together on the tomb by virtue of their own weight.

The Death of the Virgin (Fig. 14; Paris, Louvre) is one of Caravaggio's last paintings executed before his exile from Rome. The same dark, high-ceilinged room, the same imaginary light which reveals or conceals, according to pictorial pattern, instead of natural light; the same diagonal composition, which makes the figures seem to occupy space; the same lack of movement or agitation. The painting has a profound expression of mourning, due to the concentration of sorrow and

despair around the body of the Madonna. It too was rejected by the church because it was said that Caravaggio's model for the Madonna was the body of a suicide recovered from the Tiber. Too human, too real, this great tragedy could not be approved by the priests of the Counter Reformation. However, at the time of its rejection there was a young man in Rome, Peter Paul Rubens, who advised the Duke of Mantua to buy it, and he did. Meanwhile, talk of the painting had spread throughout Rome, so that before sending it to Mantua the Duke's agent had to satisfy the demand of the Roman painters by a public exhibition of it. A large, enthusiastic crowd gathered. This was in April, 1607, after Caravaggio's exile. He may have had some idea of his vindication, but he could not have foretold that his defender, Rubens, would occupy so great a place in the history of art.

The Supper at Emmaus (Fig. 15; Milan, Brera), also one of Caravaggio's late works, is one of his best examples of light engulfing plastic form, with the expression becoming more spiritual. This work foreshadowed the luministic style of Rembrandt. The same can be said of the *Nativity* (Messina Museum), probably painted by Caravaggio a year before his death. It is so solidly composed, so calm and assured in its expression, that we can see him as an artist escaping from the wild, tortured life he was compelled to live.

If we recapitulate the successive phases in the development of Caravaggio's style, we shall see more clearly the inner coherence that binds these phases together.

In his early period, his longing for truth was directed toward physical rather than spiritual representation. The *Bacchus* of the Uffizi is perhaps the most typical example of this trend. It was truth, but a limited truth; it was fully realized because Caravaggio had behind him the great Renaissance tradition. His creative power became greater and deeper when he organized all his images within a general effect of light and shade. Then the importance of the body decreased and that of the expression increased. Soon it appeared that this expression was not only psychological but also magical. Great sorrows always deepen the human soul, and so it was with Caravaggio. His only limitation was his lack of self-control in his conduct of his life. However, he opened the doors to that pictorial civilization which wanted an intimate rather than an external truth.

MANET

WHAT HAPPENED in the history of European art after Giorgione and Caravaggio is well-known. Realism was very successful in private collections, classicism was dominant in the churches and the public buildings, and baroque decoration, which was an escape from both realism and classicism, covered the vaults of the churches and the walls of the palaces. Everything was decorated with painting. A reaction followed in the form of neoclassicism, which triumphed in the second half of the eighteenth century and continued into the nineteenth century in spite of the new trends of romanticism and realism. Neoclassicists were considered the natural heirs of the Italian Renaissance and of Greek antiquity, the imitators of a past art, of a perfection which could not be attained again. Theirs was a system of rules rather than an impulse to create—a refined Academy of Artistic Sciences. During the first half of the nineteenth century the Academy had its best period; almost all the academicians were exalted as new Raphaels, while the romanticists were placed on a lower level, unworthy of the confidence of the government and of the élite. The convictions of the academicians were so widespread that even the greatest painters, those who were the forces behind the revolutions of romanticism and realism, were intimidated

by the rules of the Academy and tried to compromise with it. They chose subject matter different from that preferred by neoclassicists, as for example historical scenes of the Middle Ages rather than of Greek and Roman antiquity, events of contemporary life rather than of mythology. They gave a new importance to the harmony of coloring and to the movement of figures, but the system of drawing inherited from the Renaissance did not change. The change in the conception of drawing was the innovation of Manet and the impressionists.[1]

It is well to recall here that Manet painted his most famous painting, *Olympia*, in 1863. Ingres was still alive; he had been deified by Napoleon III and his court in 1855 as the greatest representative of the beautiful, and in recognition he had been appointed a senator of the Empire. When he died, in 1867, four years after Manet painted the *Olympia*, it was officially declared that outside the perfection which goes from Homer to Ingres all was fashion and caprice.

The man who wanted to destroy the prejudice in favor of the ideal—of perfect beauty—and who affirmed his anti-classicism with the greatest emphasis was Eugène Delacroix. "If," he wrote, "one understands by my romanticism the free manifestation of my personal impressions, my antipathy to the types invariably copied in the schools, and my repugnance

toward academic recipes, I must confess that I am a romantic." [2] In fact, Delacroix did more than anyone before him to renew the conception of form, to liberate it from the idea of Greek sculpture and of Greek beauty. However, he was too busy with his romantic subject matter, with literature and poetry, to avoid making some compromise. Above all, when he painted the female body, he respected the tradition of form.

When we consider the painting of Gustave Courbet, we become aware that he felt the necessity to free himself from the academic rules of form much less acutely than did Delacroix. Charles Baudelaire pointed out that Courbet was a powerful artisan and that, as far as the solidity of form was concerned, his painting was somewhat similar to that of Ingres.[3] In fact, the great realist profited by the art of the past in order to show the power of his execution, and he openly admitted that his origins went back to Gros and to Géricault, that is, to a conception of form older than that of Delacroix —less spiritual, less poetic, still tied to the tradition of the Renaissance.

This was the state of painting when Edouard Manet began to work. He learned from Couture a technique which was generally academic rather than classic or romantic or realistic.

We know that Manet rebelled against the teaching of Couture, but he remained in his school for six years, and then he studied Velázquez, Goya, Raphael, and Frans Hals. He looked on himself as a rebel, but he knew neither the nature nor the aim of his rebellion. True, he was aware of the evils of historical painting, as was Courbet, and he longed for a not too finished form, like that of Delacroix. But at the same time he disliked Courbet, whom he considered vulgar, and he did not like Delacroix, for romanticism was no longer fashionable among the young dandies of 1860.

As Manet's friend, Antonin Proust, tells us, "He would sketch a mere nothing in a notebook—a profile, a hat, a fleeting impression—and the next day a friend, catching sight of it, would say, 'You ought to finish that.' Manet would laugh. 'Do you take me for a historical painter?' *Historical painter*, in his mouth, was the most damning insult that could be hurled at an artist. 'There is nothing more ludicrous,' he would say, 'than to reconstruct historical figures. Do you paint a man according to the description given on his hunting license? There is only one thing that is real: to put down immediately, with one stroke, what you see. When you get it, you have it. When you don't get it, you try again. Everything else is nonsense!' " [4]

We have already considered this question of the unfinished. We have seen how Giorgione, Leonardo, and Michelangelo felt it necessary to go beyond the workmanship of the artisan and to stress that a painting must be above all the work of the mind. Later, the ability of the hand became more and more appreciated. No doubt, everybody admired in a painting of Courbet the work of the hand rather than its spiritual values. By stressing the unfinished, Manet reasserted a desire for spiritual values within the limits of form itself. Classicism, romanticism, realism were ideals forced on art by intellectual or moral principles. But the ideal of the unfinished was necessary from the very conception of the painting and was a denial of the popular illusion that art should merely imitate nature. For a realistic finish Manet substituted a pictorial finish.

Two great painters, Constable and Corot, had faced the same problem about forty years before Manet. They achieved some of their masterpieces by stopping the painting as soon as they became aware that they had expressed their imagination completely and before they reached the illusion of reality. But they knew that their masterpieces were excluded from the exhibitions of the Royal Academy and the Parisian Salon, where only illusionistic finish was admitted. Constable made

pairs of paintings, of which one was for himself and the other
for the Royal Academy. In the second he lost a great deal of
the artistic value previously created. Corot did not dare send
to the Salon his *Bridge at Narni*, which we admire now in the
Louvre as one of his greatest masterpieces. Instead he painted
a replica, now at the National Gallery, Ottawa, which shows
a pointless return to the tradition of the seventeenth century.
He looked to the future for himself and to the past for the
Salon.

Manet refused to bow to the taste of the Academy and of
the public. He exhibited his new "unfinished" interpretations
of reality. The public did not recognize the reality in them and
protested violently. Manet stuck to his principles, was refused,
and opened a one-man show in 1867 outside the general
exhibition. He wrote in the catalogue: "Monsieur Manet has
never desired to protest. Quite the contrary, to his surprise,
others protested against him. There is a traditional way of
teaching forms, methods, visualization, painting: those who
are trained in such principles admit no others and thus acquire
a naïve intolerance. Anything outside their formulas must be
without value. . . . M. Manet . . . has never claimed to
overthrow an old form of painting or to create a new one. He
has merely tried to be himself, and no one else." [5]

In spite of his sincere desire to avoid too much struggle, Manet was considered the Enemy Number One by the Academy, who could not pardon him his independence from the illusionistic reproduction of reality.

An artist frees himself from a tradition in order to attain a new ideal. The traditional ideal was beauty. Delacroix invented a new kind of beauty; Courbet denied beauty in order to stick to reality; Manet disregarded not only reality but also beauty. What then was the ideal of Manet? To use his mind in order to isolate his sensibility and to keep it free from any preconceived direction. Sensibility is at the base of any creation in art, but for the majority of the artists sensibility is a starting point to reach either reality or beauty. Can sensibility alone become an ideal? Certainly, under given conditions. The external reality is for any painter a kind of chaos out of which the painter must select some elements and reject others in order to make a whole. This whole can be created according to the principle of perfect beauty and the result is idealistic painting. But suppose that the painter be subjective in the sense that he only organizes the impressions received from reality and thereby creates impressions coherent in themselves without modification through checking them either

against reality or against ideal beauty. What would be the result? The expression of a way of seeing, of a pure vision, of a plastic-chromatic whole, of form for form's sake. Romanticists and realists had reformed the content of art; Manet first offered a new system of form, without even suspecting that it was a new system. This is the new element brought by Manet to modern art, this is the breaking point, forced by Manet, which resulted in the birth of modern art.

The painting in which this new system appears is the *Olympia* (Fig. 16). In the same year, 1863, Manet painted *The Picnic* (Fig. 17), in which he represented a nude young woman, Victorine Meurend, his preferred model. The pose shows a desire to reduce the mass to a light relief, but the painter still pays his homage to the beauty of his model. But when he painted *Olympia* some months later, he sacrificed the fascination with beauty to the coherence of his vision. He transformed the woman into something which is at the same time an idol and a marionette. The relief is light but firm and solid, with dark contours to stress the energy of form; that is, the clearness of the image is much stronger than its relief. The same clearness appears in the other objects represented— the cushion, the sheets, the flowered scarf, the dress of the colored maid—so that the general effect is of zones of clear

colors distributed over a surface, on a background of dark colors. There is no transition from light to dark, no chiaroscuro. Because chiaroscuro attenuates the brilliance and the purity of colors, its absence means that the color becomes rich even when it is not intense. Every element depends on this general effect, which is achieved by presenting zones of colors so consistent and powerful that their plasticity is accentuated in spite of the lightness of their relief.

The secret of the powerful effect is in the presence, the immediacy, the rapidity, the magic of the appearance. Beauty, truth, life—everything is absorbed into art. This was not the art for art's sake which Théophile Gautier was preaching and which was only a formula for appreciating the beauty of Ingres.[6] It was a free creation which contained a principle of which the artist himself was unaware but which opened the way to modern art—the principle of the *autonomy of art*.

This great discovery was due only to Manet's spirit of independence, to his faith in the art he himself created rather than in the things he saw in nature or in the works of the great artists of the past.

Needless to say, the female nude has been a favorite subject matter of many painters. Besides Giorgione's *Venus*, discussed earlier, it is easy to recall one of Titian's Venuses (Fig.

18). Here the presentation of the beautiful nude is integrated with the representation of a reclining lady waiting for her clothes, which her maid is taking from a chest in the back of the room. The painting is not only the portrait of an undressed woman but also of an incidental moment in her life.

The *Venus* of Velázquez has a greater realistic imprint and an unsurpassed energy in imposing the force of material beauty upon the beholder. Goya conceived his *Maja desnuda* (Fig. 19) as a woman who offers herself, with a hint of irony in her pretended modesty. No doubt, from a psychological point of view, the *Maja* is closer to the *Olympia* than are other nudes. But what Manet did seems detached from all previous works with a sharp distinction.

Almost contemporary with the *Olympia* was the *Woman with a Parrot* (Fig. 20) by Courbet, one of the greatest mistakes of that artist. Here one can see the awful fusion of the academic and the realistic. The transformation of reality into art and the consequent autonomy of art in the *Olympia* become even clearer after one has looked at a Courbet.

Until 1870 and the Franco-Prussian War, Manet painted some marvelous and some less successful works, without de-

parting from the principles realized in the *Olympia*. As examples, *The Fifer* (1866; Paris, Louvre) and a fragment of the *Execution of Maximilian* (1867), a soldier examining his rifle (London, National Gallery) may be mentioned. After 1870 Manet understood two facts he had neglected before. The first was the importance of landscape painting in the tradition of his day. Landscape painting was recognized as a special genre in the seventeenth century, and from 1830 on it assumed a certain leadership in taste. One may ask today whether Corot did not have a larger and deeper influence on painting than did Delacroix. It was perhaps easier to reach the autonomy of art in a landscape than in human images, which had to obey conventions thousands of years old.

The figures of Corot are today considered among his masterpieces (for example, the *Woman with a Pearl*), but his contemporaries did not favor them, for Corot did not obey a rule important for figure painters. These liked to show the interior construction of their figures, conceived of as a process from the inside to the outside. Corot, on the contrary, imagined his figures from the outside, that is, from the effects of light and atmosphere reflected on the bodies—hence the softness and grace of his figures. This meant that his figures did not appear as detached from their environment but as immersed

in the surrounding atmosphere. In other words, Corot reflects in his figures his landscape experience; the style of his figures is a landscapist's style.

Now it is well to recall that impressionism was born in landscape experiment. Monet and Renoir were painting at the Grenouillère (see Fig. 21) when they first understood what they might achieve by the division of the colors they saw in the reflections of things in the water. One can say that when the realistic observation of the division of colors in the watery reflections was assumed as a principle of style, and that when the vibration of light was extended to all the elements of a painting, this was the moment when impressionism was born. Such a style was of course more easily realized in landscape painting than in figures. It was Renoir, as is well-known, who first was able to find an impressionistic interpretation of figures and to draw from it a new and unsurpassable grace.

Manet did not care very much to paint landscapes before 1870, nor was he sympathetic toward Claude Monet or the impressionists. In spite of the affinity of their art, and in spite of the hostility of the Salon and the Academy, he did not want to exhibit with the impressionists. But from 1873 he assimilated from Claude Monet the technique of the division

of colors and of the light effects which the impressionists had mastered in the meantime.

The Croquet Game (1873) shows how Manet realized the human form perfectly, in accordance with the light-filled forms of the trees. *The Road Menders, rue de Berne* (Fig. 22; 1878) shows a brilliancy of light and shade, a vibration of touch, and a vitality in the whole picture on a level that the impressionist seldom attained. The same must be said of some paintings of flowers, for example *Peonies in a Vase* (1883).

The realization of impressionism in the human figure was difficult also for Manet. A good approach was *In the Boat* (Fig. 23; 1874; New York, Metropolitan Museum). Here one sees human figures created by the light itself and transformed into sunny phantasms. But the picture in which Manet achieved an impressionistic vision of figures in his best manner is *The Waitress* (Fig. 24; 1878; London, National Gallery). The foreground shows a compact group of images, extremely varied in light, shadow, and contrasts and organized as a single image of light and shadow transcending the separate figures. The transformation into light and shadow of everything in the picture is complete.

Before 1870 Manet realized an autonomous form of art

that went farther than the dictates of nature or of beauty. After 1870, thanks to impressionism, Manet's autonomy was a synthesis of form, color, and light. One can say that he offered to the impressionists an aesthetic and received from them a technique. The fact is that at the beginning of the modern autonomy of art, the name of Manet must be inscribed first.

In 1883, the year of Manet's death, Jules Laforgue [7] explained that impressionism was not the equivalent of a fleeting reality but the report of an optical sensibility. That is, Laforgue understood that the impressionist's coherence of imagination was no longer enslaved to the control of reality but that it was a production of vision justified by vision itself and by nothing else. Laforgue could not have understood this if he had not known Conrad Fiedler's theory of pure vision.

No doubt Manet knew nothing of Fiedler or of any philosophical aesthetics, but he invented an art which could exemplify Fiedler's theory more than did that of any one else in modern times. The autonomy of art based on pure vision was the meeting point of both art and aesthetics at the end of the nineteenth century.

CÉZANNE

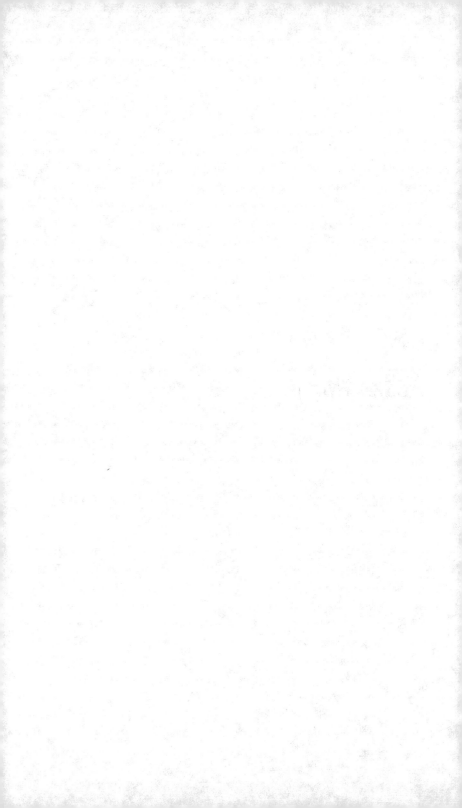

WHEN WE SPEAK of modern art in the sense of the art of today or of the first half of the twentieth century, we must admit that cubism has dominated the whole period. The first of the revolutions in taste of our century was fauvism, not cubism; but fauvism did not last and was submerged by cubism. Other movements were even more popular than cubism, for example expressionism and futurism, but today we feel that they are outdated. Cubism, on the contrary, is as alive today as it was forty years ago, even if it is now very different from what it was then. But it is characteristic of really vital movements that they change in order to answer new problems, and the fundamental exigency of cubism—to interpret reality by abstract geometrical forms in order to realize the autonomy of art—appears quite vital today. All modern architecture and decoration originated in cubism. Cubism could be defined as the renaissance of that architectural consciousness which the nineteenth century had lost.

Fauvism and expressionism owe their origin to Gauguin and to Van Gogh. But cubism descends from Paul Cézanne. This man,[1] who was born in the south of France, in Aix-en-Provence, in 1839 and died there in 1906, had the most complex and complete conception of art, a conception of such a

grandeur that it has been considered by generations of paint-ers as their best model. The lesson of Cézanne obtained a popularity even greater than did his art itself, but naturally it is to be found in the ultimate development of his art rather than in what he said or wrote in some letters.

The first period of his maturity falls between 1865 and 1871. He wanted to be a realist, he used the knife instead of the brush for his layers of tints, he brutalized his friends who agreed to become his models, but his heedless sensuality and passionate temperament prevented him from representing reality. He looked much more to the torments of his inner nature than to the life of external reality. His images were more magic than real, more expressionistic than representa-tive of an object.

Beginning in 1872, Camille Pissarro suggested to Cézanne that he care more for outward reality than for his inner pas-sions. Cézanne learned not only to represent roads, thatched cottages, fields, and trees but also to suggest the effect of light and shade through the spots of the impressionistic technique. This was a system that Cézanne used until the end of his life, because he did not wish to renounce the vitality that repre-sentation acquires through impressionistic technique. The blues of the shadows and the oranges of the lights give to the

whole a splendor which it would be impossible to obtain through chiaroscuro.

After 1878 Cézanne withdrew from the impressionist group because he felt it necessary to meditate and to find, as he said, the theory of his own art. Here one must recall that about the same year the majority of the impressionists separated from the group in order to follow individualistic lines. The line followed by Cézanne was characterized by the substitution of a visual construction in depth for the presentation of the elements on the surface, which the impressionists preferred. This revaluation of the third dimension was made by Cézanne in order to connect impressionism with the great art of the past that can be seen in the museums. The new order imagined by Cézanne needed the suggestion of geometrical forms, as he said in 1904: "See nature as cylinder, sphere, and cone, the whole placed in perspective, so that each side of an object or plane is directed toward a central point. . . . Nature is for us more a matter of depth than of surface—whence the necessity of introducing into the vibrations of light, represented by reds and yellows, a sufficient number of bluish tones to give a feeling of air." [2] Architectural construction, geometrical forms, integration of orange and blue, these were the three elements which, put together, allowed Cézanne to realize his

plastic-chromatic vision in depth. Hence his love for volumes
—that is, for plastic forms realized through colors.

When he wanted to paint a motif in the distance—the
Montagne Sainte-Victoire or the Gulf of Marseilles—he was
compelled to bring forward the objects seen at the horizon.
But he had to compensate this visual distortion. He preserved
the space relationship between nearness and distance, choos-
ing to change the foreground and make it more distant than
in reality. That is, he abstracted both foreground and back-
ground from their real positions and excluded from the space
of the picture the place where he was standing, and hence any
subjective reference. Thus Cézanne organized an objective
relationship, objective not with respect to nature but with re-
spect to the picture, to art. The autonomy of art in the face of
nature became more complete than that of the impressionists,
became a new world, a world of imagination which was de-
veloping along a line parallel to that of nature, meeting it
only in the infinite.

Cézanne did not limit himself to those distortions that were
necessary by his diminishing the actual distance of far-away
objects. He also felt the necessity of knowing the objects
from more than one point of view. Knowledge of an object be-
comes more and more complete if one looks at it by moving

around it. Above all, its three-dimensional character is emphasized by representing it from various points of view; such representation is at the same time distorted and full of an exceptional vital energy. Cézanne used the variety of points of view not only in still lifes but also in landscapes and portraits. Yet he always knew how to preserve the verisimilitude of this unified vision—that is, the parallel between artistic and natural vision. Cubists, taking advantage of their liberation from the single point of view, did not maintain the verisimilitude of a natural vision; thus they brought to the same plane two eyes in a profile. That is, they gave a succession of the different aspects of an object instead of a simultaneous vision of it. Thus the result of cubism was very different from that obtained by Cézanne, who had originated it.

Here is one of the most important breaks between modern art and the art of the past. Since the time of Brunelleschi and Masaccio, the vision of space had been regulated by geometrical perspective. Unity of space became a rule which even the impressionists obeyed. But Cézanne destroyed unity of space by using different points of view and creating a succession of visions.

What is astonishing is that at the same time, in his *Essai sur les données immédiates de la conscience,* published in

1888, Bergson modified the idea of space. He considered the time continuum (*durée*) as the only basis of consciousness, and he reduced space to a single projection of time. He said that "each of the so-called successive states of the external world exists alone; their multiplicity is real only for a consciousness that can first retain them and then set them side by side by externalizing them in relation to one another." [3] The juxtaposition of the objects in space painted by Cézanne and those theorized by Bergson shows a truly impressive unity of sensibility, imagination, and thinking. It was one of the earliest portents of the revolutions which took place in our century in the field of art as well as in that of science.

After Cézanne achieved his new artistic autonomy both in form and color, around 1895, he painted in oil and water color with great ease, never forgetting to enrich his ideal construction and at the same time insisting on keeping the vitality of impressionistic coloring and even the magic effects he had learned in his early years. Encouraged by the enthusiasm of the young painters after many years of oblivion and disregard, he worked hard until his death in 1906.

Two examples of Cézanne's art in his earlier period are *Melting Snow* and *The Temptation of Saint Anthony*. *Melt-*

ing Snow (about 1870), shows an unusual violence of contrast in the highlights and shadows. The trees, the mountain slopes, and the clouds appear to be on the point of being carried away by the fury of the wind. The contrasting light and shade, therefore, depict the great force of the wind and the fury of the artist's romantic passion.

The Temptation of Saint Anthony not only presents those same contrasts of light and shade but also exemplifies the relative unimportance of figure drawing as compared with the effect of fear—just as if the temptation were a nightmare. Here it is well to remember that Flaubert, too, visualized the temptation of Saint Anthony as a nightmare. Farther than this romantic fancy cannot go.

Between 1865 and 1870 Cézanne's best pictures were portraits and still lifes. A fine example is *Oncle Dominique* (Fig. 25). It is painted with a knife used in such a way that the very thick paint acquires value as form. The sudden transition from the black to the pink of the flesh tints does not suit a relief effect, which requires a modulation of chiaroscuro. Nevertheless, a suggestion of relief is not entirely absent from the form impressed by the spatula on the color. Cézanne seeks form in this method of applying color instead of in chiaroscuro. His form is massive, impressively square.

In 1874, at the first impressionist exhibition, Cézanne exhibited three pictures, including *The House of the Hanged Man* at Auvers-sur-Oise. There is a vestige of romanticism in this title, but not in the picture itself, nor for that matter in the house, in which no one was ever hanged. We have before us a poor cottage, a village street, and a few bare trees. The exact spot in Auvers can still be found: the old thatched roof has been replaced by slate, the road has been somewhat improved, and the whole subject lacks interest. But by seeking the poetic motive within, not outside, the vision, Cézanne freed himself from romantic prejudices and fantastic tendencies. The twofold transverse direction of the roads and their difference in level allow space to be created. The roughness of the buildings facilitates the rendering of volumes (instead of contours) and the development of an open form. And volume is to open form what relief is to closed form. Here Cézanne at once attains monumentality. His ardent imagination is no longer centrifugal but penetrates to the heart of things. He realizes his ideals completely.

When around 1876 he executed the *Boundary Wall* (Fig. 26), his colors had become more varied and intense. The wall is violet, and reflected on it are the blues of the trees; the meadow is green, the earth is yellow-green, the tree trunks

grey or grey-brown, the leaves green, and a yellow branch
extends to the center; the roofs are red, and the sky is grey.
The brushwork is short and varies in direction. On the wall,
shadows are playing with an intensity of chromatic complexity
like that found in the impressionistic reflections in water
painted first by Monet, then by Pissarro and Sisley. The
effect of space is obtained both from the transverse direction
of the wall and from the contrasts between the trees and the
sky and between the wall and the houses. The motive, the
methods, the forms, and the colors are *all* impressionist, but
conceived with a stability and a monumentality that are
Cézanne's own.

How impressionism suggested to Cézanne the full manifes-
tation of his form can be seen in the *Portrait of Victor
Choquet* (Fig. 27), one of the first of the painter's enthusiastic
admirers and a collector of his works. The effect is that of dark
tones superposed on light, with an infinite blending of colors
which accord with the shimmering light, identifying the
light with the image. The method is particularly complex,
yet how simple is the effect, for no synthesis could be more
rigorous. It has been said that beneath that tremulous light
there is a severe form. But it should be observed that the form
is neither underneath nor above, for the extreme severity of

form proceeds from that quivering light itself. From the perfect unity of form and color emerges the man, sensitive, grave, sorrowful, and masterful, living in greatest rectitude. Compared with *Oncle Dominique*, the *Choquet* canvas is not only a great step forward in the discovery of a style, it is above all perfect art.

After his impressionistic period, as we said, Cézanne retired from the group of his friends in order to find the solitude that would enable him to justify his endeavors theoretically by giving a geometrical order to his compositions.

Houses in Provence (Fig. 28) shows a minimum of doors and windows in order to draw attention to the clear surfaces, seen here in sunlight, there in shade. So with the earth and rocks: the relief is given by their surfaces. The entire geometrical scheme is carried out through the mass of sensuous objects—this house, that rock. In fact, this sensuous quality is so strong that the conception seems almost naïve. In 1905 Cézanne wrote to Emile Bernard that one had to express the image of what one sees, ignoring everything one had seen before.[4] In this picture he has indeed realized his desire to become "primitive."

From the slopes of a hill above the village of L'Estaque one overlooks the glorious Gulf of Marseilles. In the example at

the Metropolitan Museum (Frontispiece), Cézanne imagines
the surface of the sea as slanted so as to show its mass, without
on this account losing the feeling of distance. The mass of the
sea is neither near nor distant, there is no subjective relation-
ship to act as a guide to things. It is sufficient that the planes
are interrelated and have their own imaginative explanation.
Hence the representation is perfectly objective, not in relation
to nature, but to art. In nature, "near" and "far" are material
terms in a finite world. Cézanne's work is so coherent, so
self-sufficient, that it belongs to no particular world: it is a
world unto itself, dwelling in the infinite and the universal,
with the solemnity of things that have existed from eternity.

This imaginative world is of incomparable chromatic splen-
dor. The whole color harmony is intense but at the same time
restful, with a firmness of poise like that of the composition.
Cézanne said, "There is neither light nor dark painting, there
are simply tone relations. When these are realized correctly,
harmony is automatically established. The more numerous and
varied they are, the more they please the eye." [5] Compared
to the *Houses in Provence*, *L'Estaque* not only has a larger
conception, more variety of elements and synthetic stability,
but also greater perfection of execution. Cézanne no longer
needs short straight strokes in order to construct his order;

he already paints by little touches and accents and is able to vary the effects infinitely. Variety enlivens the stability of form.

Geometrical order is accentuated in *Madame Cézanne in the Conservatory* (Fig. 29), as may be seen by the rounded shape of the forehead, by the placing of the facial oval in relation to the line of the hair, like an egg in an egg cup, and by the regularity of the features. Even in the reproduction it can be seen that the light and shade of the colors are the predominant elements; they are the very breath of this spontaneous figure, and one feels that Cézanne painted as the almond tree produces its blossoms.

In this same period Cézanne painted his series of *Card Players*. The best commentary on the example reproduced here (Fig. 30) is, I think, the remark of Cézanne: "I love above all the look of the people who have grown old without doing violence to good customs, submitting to the laws of time. Look at this old innkeeper: what style!" [6]

Let us obey the laws of time and nature, and live in truth! That is the secret of the grace of Cézanne, a grace which he found, for example, in a few peasants playing cards. Think of one of Millet's peasants—a political system in himself A Cézanne peasant is as individualized as a portrait and as uni-

versal as an idea, as solemn as a monument and as solid as moral consciousness.

Another point may be discussed. It has been said that the intensity of the pictorial detail in *The Card Players* spoils the ensemble. But observe the firmness and character of the figures and the vitality of the composition, and you will feel the reality of the ensemble. True, Cézanne wrote to Bernard on October 23, 1905, "The color sensations, which produce the light, cause abstractions that do not allow me either to cover my canvas or to follow to the end the delimitation of the objects when the points of contact are tenuous and delicate: as a result my picture is incomplete." [7] But even allowing for the cautious reserve of self-criticism, admitting that Cézanne was sincerely convinced of the truth of what he had written, one must recognize that on this point he has not done theoretical justice to his picture, for its reality lies elsewhere. Certainly I see that there is a separation between the hands and the sleeves of the players, that there is a lack of firm and delicate points of contact. But any contact point whatever would have been foreign to Cézanne's style. In order to explain this matter, I think it is well to have recourse to a happy distinction which he himself suggested to Bernard: "No modeling, but modulation." In the original meaning of the word, "to

model" is "to realize the structure of a body," and "to modulate" is "to pass from one key to another." The ensemble of a figure or a composition by Cézanne is produced not by any material object but by rhythm: one part of a picture is attached to another, not according to the design, but according to the relation between the planes. "To paint," he said, "is not slavishly to copy the subject; it is to find a harmony between numerous relations." The unity born of such relations is not a material but a spiritual one, giving us the character of these peasants rather than their skeletons. "To see into nature is to separate the character from the model." [8]

An example of still life which shows very clearly how Cézanne looked at the motif from different points of view is *The Kitchen Table* (Fig. 31; Paris, Louvre). The basket of fruit and the plane of the table are seen at different levels, and the left and right parts of the table cannot possibly meet under the table cloth. Through his distortion Cézanne succeeds, with an intense vitality, in realizing the individuality of each object; at the same time he finds a general order which transcends forms and colors and which depends on the energy with which the objects are presented. In other words, it is the force and the clearness of the vision which imposes itself more than nature itself can do.

For many years, until the end of his life, Cézanne worked at three large canvasses representing *Bathers*. The example at the Philadelphia Museum (Fig. 32) is the most architectural of all. Trees and figures are ordered to build up a plastic architecture of painting. Indeed, the greatness of this picture recalls the façade of a cathedral. Never was line more inspired with palpitating life; nor was ever a touch of the brush better based upon ideal structure. Cézanne was not only free from neoclassical and romantic traditions, as were his impressionist friends, he had escaped the fetters of nature as well. No one had so crystal-clear a knowledge of the parallel ways along which art and nature should run. Thus he created that second nature which all recognize as the essence of Provence and which all should accept as the modern language of painting. No other new mode of expression has that character of purification from every element extraneous to art—that character of pure painting, which is found in Cézanne. Furthermore, pure painting, second nature, abstract structure, and lively feeling are single elements which have proved their aesthetic value because they belong to that harmony of elements whose name is Cézanne.

NOTES

NOTES: *Giorgione*

1. Lionello Venturi, *Giorgione* (Rome, 1954); Arnaldo Ferrituto, *Attraverso i misteri di Giorgione* (Castelfranco, 1933).

2. Giorgio Vasari, "Vita di Giorgione," in *Le vite de' più eccellenti pittori, scultori e architetti*, Milanesi edition (Florence, 1897), IV, 96.

3. Antonio Morassi, "Esame radioscopico della Tempesta di Giorgione," in *Le Arti* (Florence, 1939), fasc. IV, pp. 567–70.

4. Johannes Wilde, "Roentgenaufnahmen der "Drei Philosophen" Giorgiones," in *Jahrbuch der kunsthistorischen Sammlungen* (Vienna, 1932), pp. 141–54.

5. Marc'Antonio Michiel, *Notizie d'opere del disegno*, Frimmel edition, in *Quellenschriften für Kunstgeschichte und Kunsttechnik* (Vienna, 1896), I, 86.

6. Hans Posse, "Die Rekonstruktion der Venus mit dem Cupid von Giorgione," in *Jahrbuch der preussischen Kunstsammlungen* (Berlin, 1931), pp. 29–35.

7. "Vita di Tiziano," *op. cit.*, V, 427.

8. *Op. cit.*, p. 106.

9. *Ibid.*

10. Recently Professor Nardi tried to identify the young man with Copernicus, who had studied at the University of Pavia. See *Il Mondo* (Rome), August 23, 1955.

NOTES: *Caravaggio*

1. See Lionello Venturi, *Caravaggio* (Novara, 1951).

2. See W. Kallab, "Caravaggio," in *Jahrbuch der kunsthistorischen Sammlungen des allerhoechsten Kaiserhauses* (Vienna, 1906–7), pp. 272–92; Lionello Venturi, "Il 1609 e la pittura italiana," in *Nuova Antologia* (Rome, December 16, 1909), pp. 613–19, "Studi su Michelangelo da Caravaggio," in *L'Arte* (Rome, 1910), pp. 191–201, and "Alcune opere inedite di Michelangelo da Caravaggio," in *Bollettino d'Arte* (Rome, 1912), pp. 1–8; Roberto Longhi, "Due opere di Caravaggio," in *L'Arte* (Rome, 1913), pp. 161–64, "Orazio Borgianni," in *L'Arte* (Rome, 1914), pp. 7–23, and "Gentileschi padre e figlia," in *L'Arte* (Rome, 1916), pp. 245–314.

3. Aldous Huxley, *Crome Yellow* (London, 1936), p. 92.

4. Lionello Venturi, "Studi radiografici sul Caravaggio," in Vol. V of *Atti dell'Accademia Nazionale dei Lincei* (Rome, 1952).

NOTES: *Manet*

1. See Lionello Venturi, *Impressionists and Symbolists* (London and New York, 1950), pp. 1–25, and *Modern Painters* (London and New York, 1947).

2. Théophile Silvestre, *Les Artistes français* (Paris, 1865), p. 61.

3. Charles Baudelaire, "Exposition universelle de 1855," in *Variétés critiques* (Paris, 1924), p. 95.

4. Antonin Proust, *Edouard Manet—Souvenirs* (Paris, 1913), pp. 29–30.

5. Adolphe Tabarant, *Manet* (Paris, 1947), p. 136.

6. Théophile Gautier, *Les Beaux Arts en Europe* (Paris, 1855), I, 142–66.

7. Jules Laforgue, *Mélanges posthumes* (Paris, 1923), pp. 136–38.

NOTES: *Cézanne*

1. See Lionello Venturi, *Cézanne, son art, son œuvre* (Paris, 1936), pp. 7–65, and *Impressionists and Symbolists* (London and New York, 1950), pp. 118–19.

2. Paul Cézanne, *Correspondance* (Paris, 1937), p. 259.

3. Henri Bergson, *Time and Free Will*, authorized Eng. tr. of *Essai sur les données immédiates de la conscience* by F. L. Pogson (London, 1913), pp. 120–21.

4. Cézanne, *op. cit.*, p. 276.

5. Venturi, *Cézanne*, p. 54.

6. *Ibid.*, p. 60.

7. Cézanne, *op. cit.*, p. 237.

8. Venturi, *Cézanne*, p. 60.

PLATES

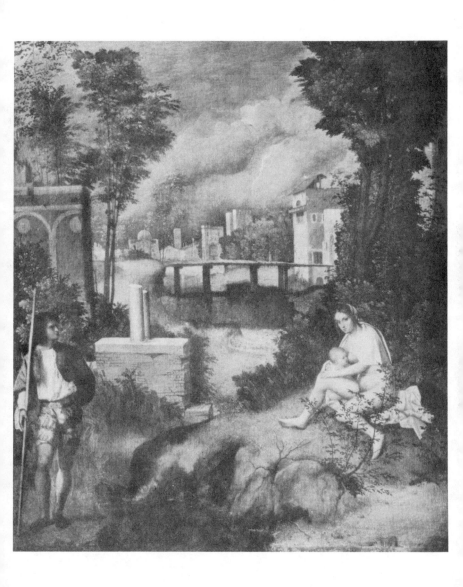

1. GIORGIONE: *The Thunderstorm*

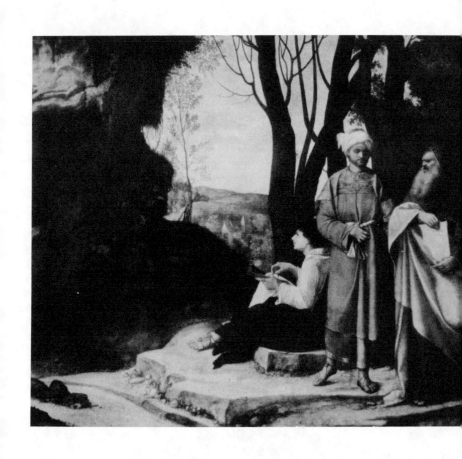

2. GIORGIONE: *The Three Philosophers*

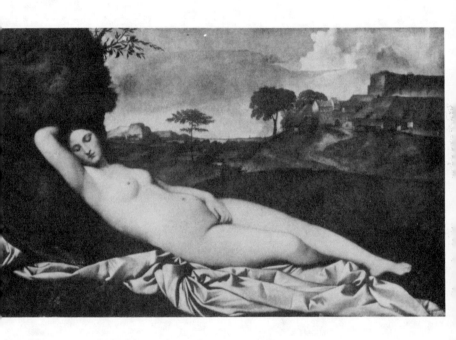

3. GIORGIONE: *Sleeping Venus*

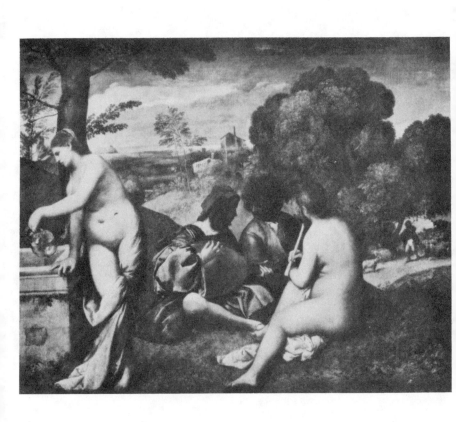

4. GIORGIONE: *Pastoral Music*

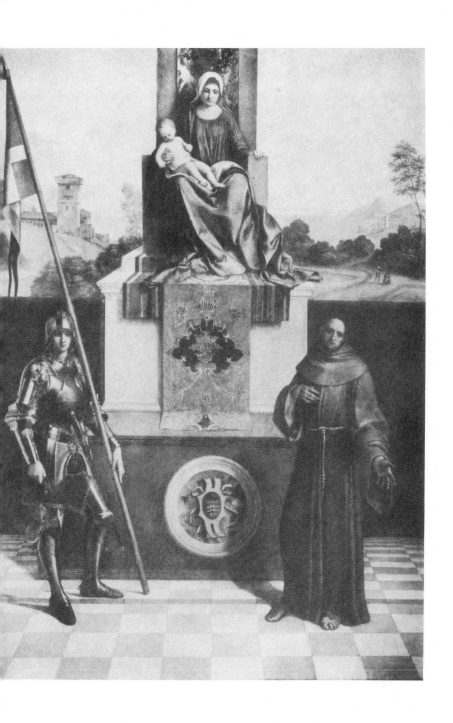

GIORGIONE: *Madonna and Saints*

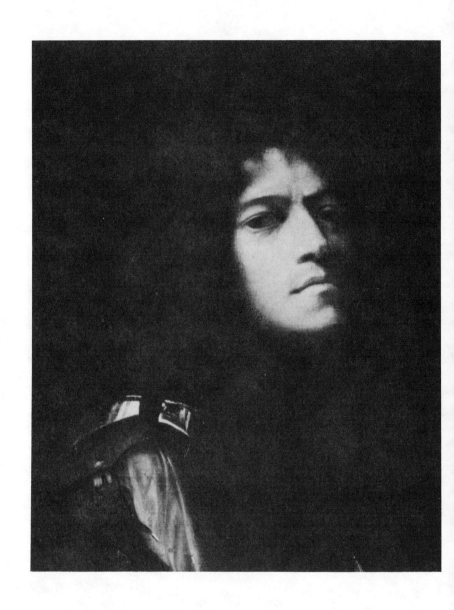

6. GIORGIONE: *Self-Portrait*

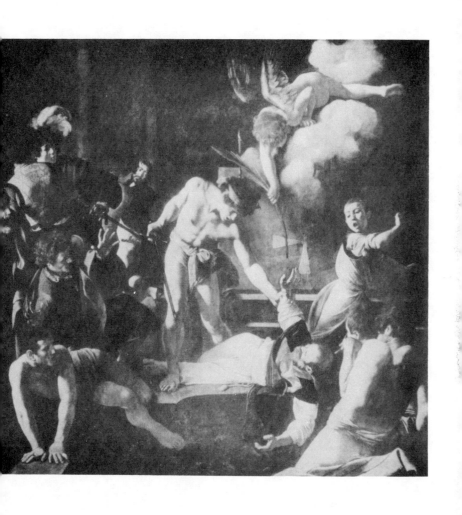

CARAVAGGIO: *The Martyrdom of Saint Matthew*

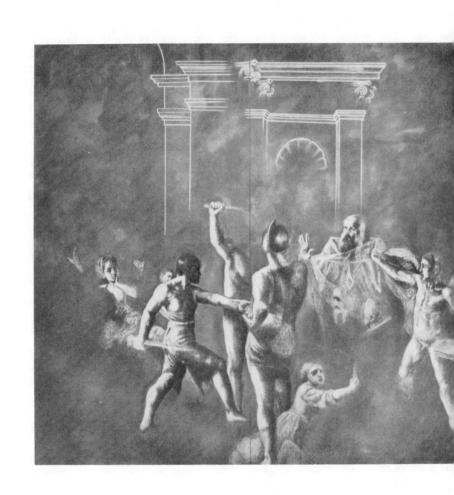

8. Caravaggio: *The Martyrdom of Saint Matthew*

DRAWING RECONSTRUCTION OF EARLIER DRAFT, MADE FROM AN X-RAY PHOTOGRAPH

PHOTO ISTITUTO CENTRALE DEL RESTAURO, ROME

9. CARAVAGGIO: *The Martyrdom of Saint Matthew*

10. CARAVAGGIO: *The Martyrdom of Saint Matthew*

DETAIL FROM X-RAY PHOTOGRAPH OF EARLIER DRAFT: THE FLEEING WOMAN

PHOTO ISTITUTO CENTRALE DEL RESTAURO, ROME

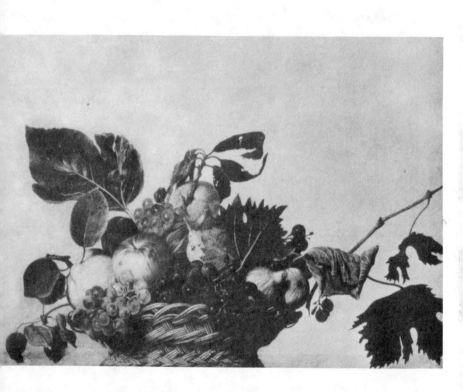

CARAVAGGIO: *The Basket of Fruit*

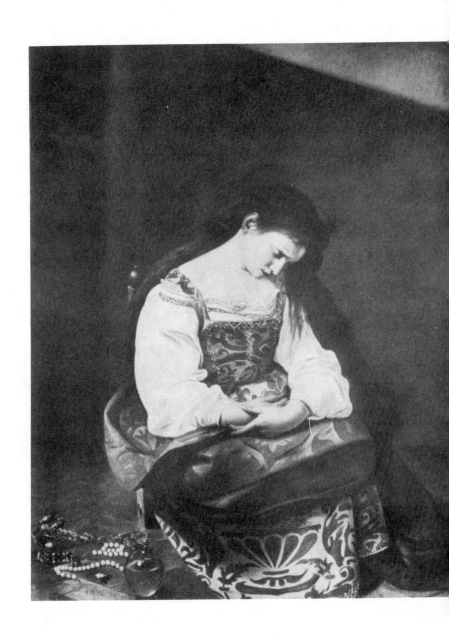

12. CARAVAGGIO: *The Magdalen*

ROME, DORIA GALLERY. PHOTO ANDERSON, ROME

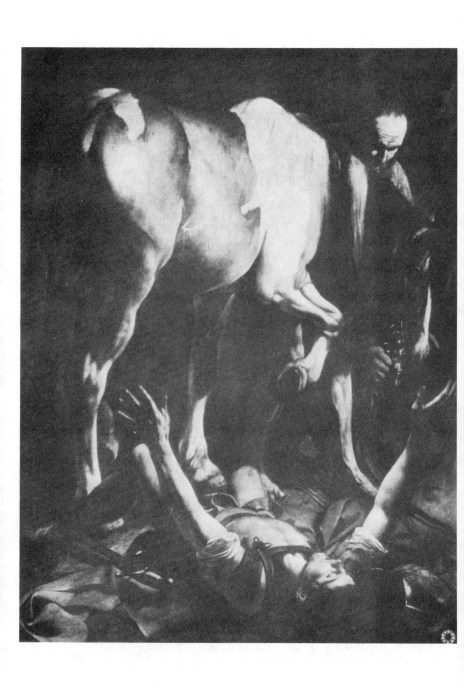

13. Caravaggio: *The Conversion of Saint Paul*

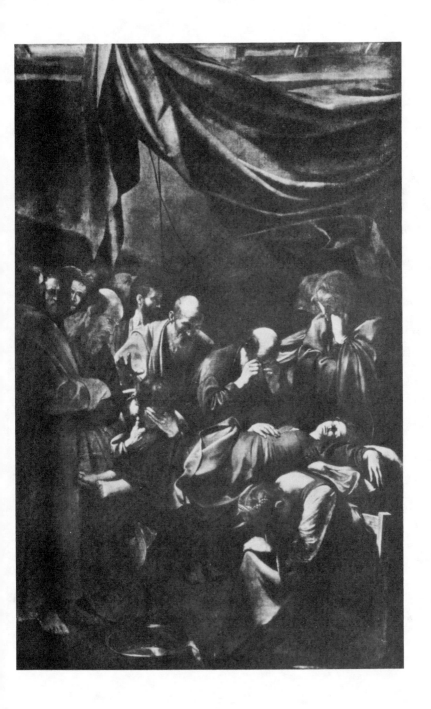

14. CARAVAGGIO: *The Death of the Virgin*

PARIS, LOUVRE. PHOTO ANDERSON, ROME

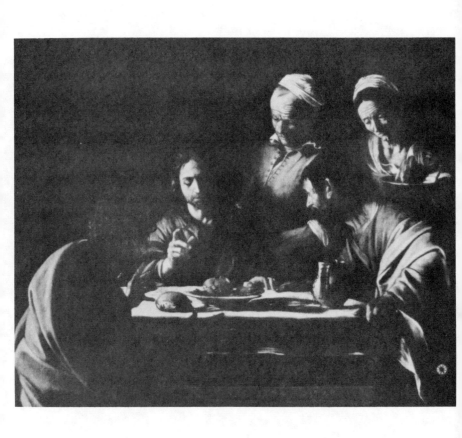

15. CARAVAGGIO: *The Supper at Emmaus*

MILAN, BRERA. PHOTO ANDERSON, ROME

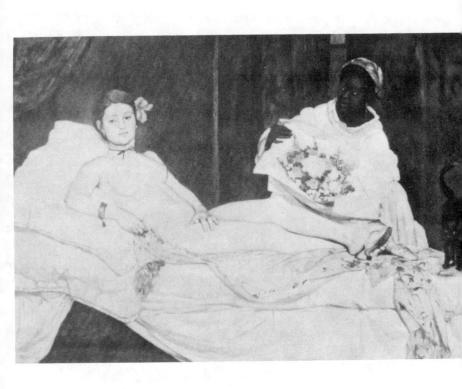

16. MANET: *Olympia*

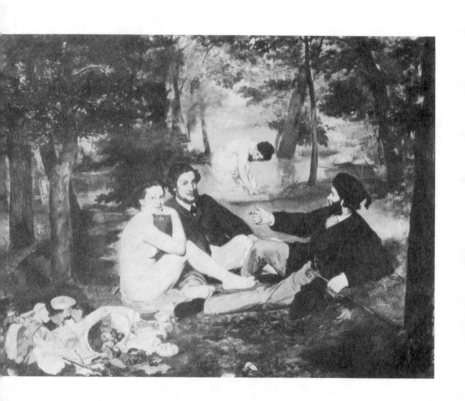

7. MANET: *The Picnic*

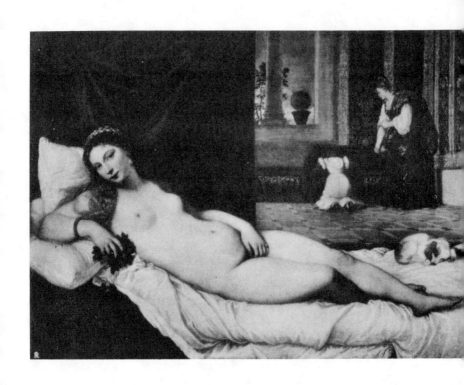

18. TITIAN: *Venus*

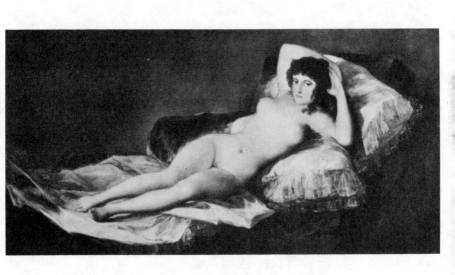

19. GOYA: *Maja Desnuda*

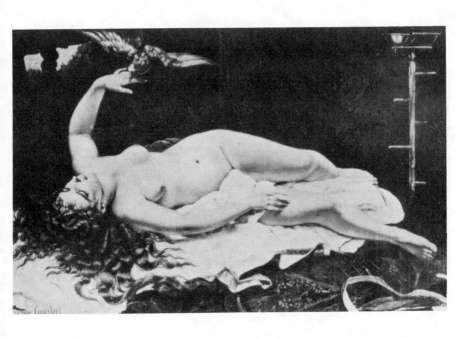

20. COURBET: *Woman with a Parrot*

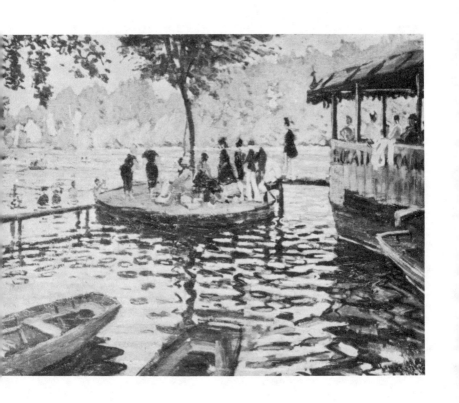

. Monet: *La Grenouillère*

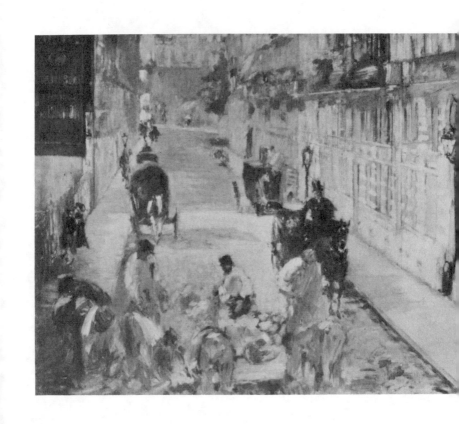

22. MANET: *Road Menders, Rue de Berne*

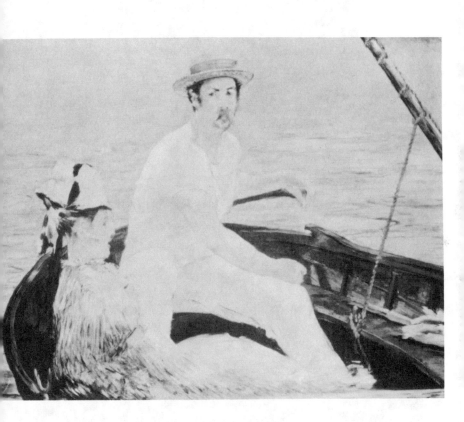

3. MANET: *In the Boat*

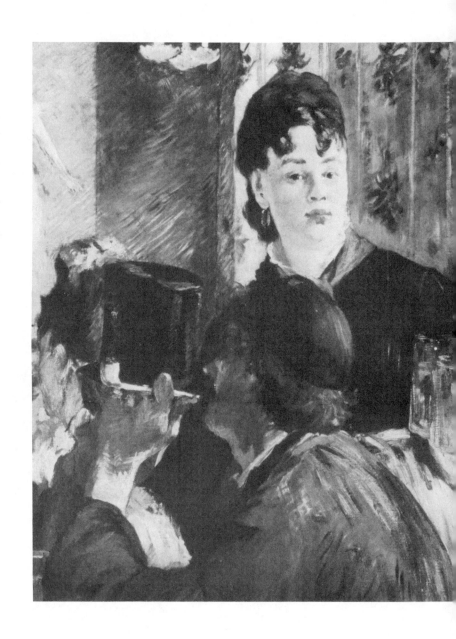

24. MANET: *The Waitress*

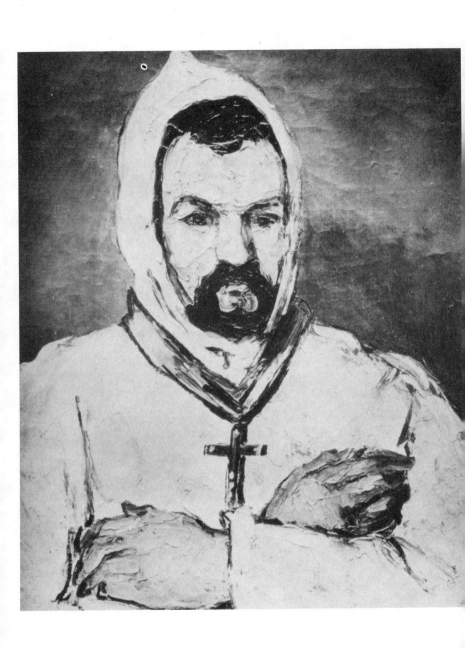

25. Cézanne: *Oncle Dominique*

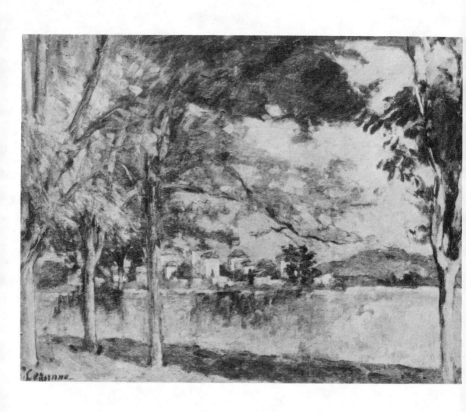

26. CÉZANNE: *Boundary Wall*

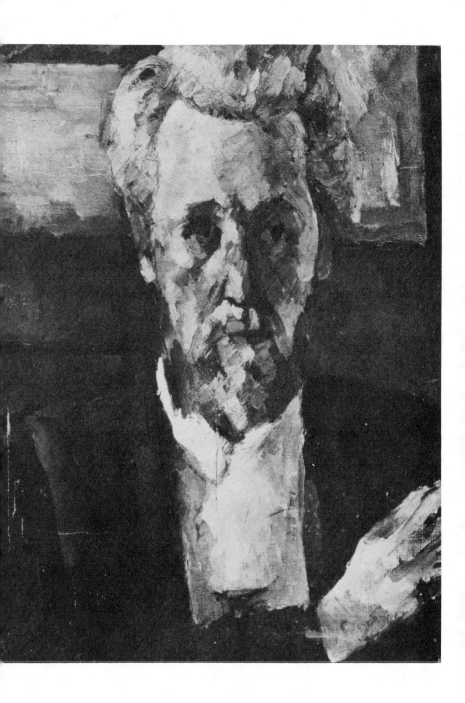

7. CÉZANNE: *Portrait of Victor Choquet*

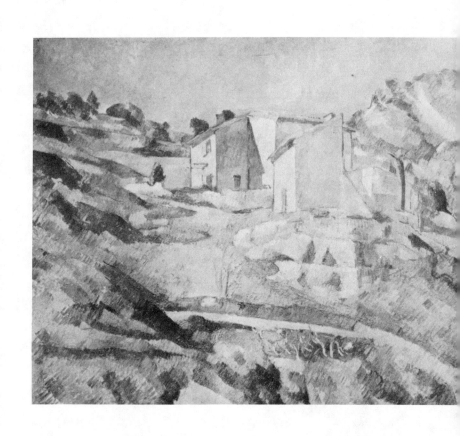

28. CÉZANNE: *Houses in Provence*

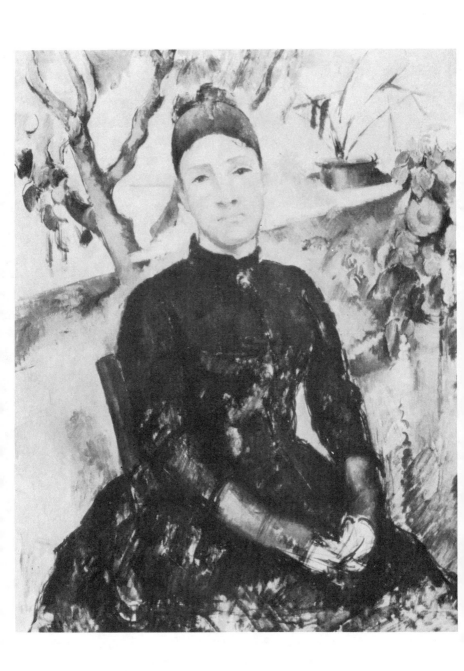

29. CÉZANNE: *Madame Cézanne in the Conservatory*

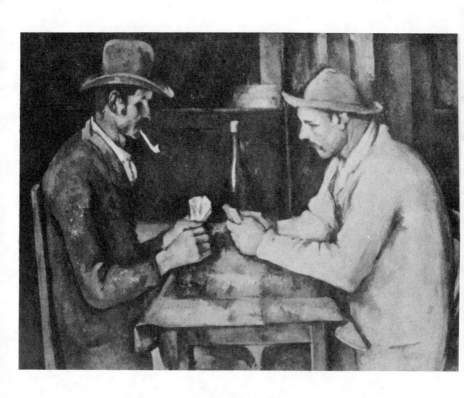

30. CÉZANNE: *Card Players*

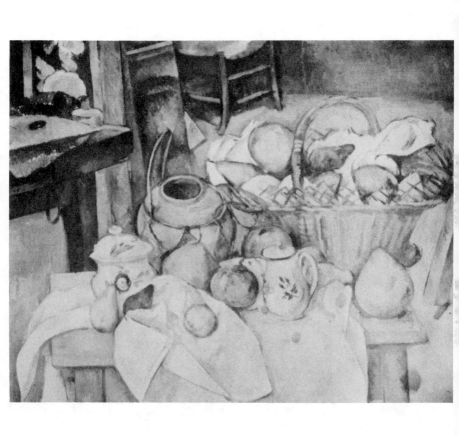

31. CÉZANNE: *The Kitchen Table*

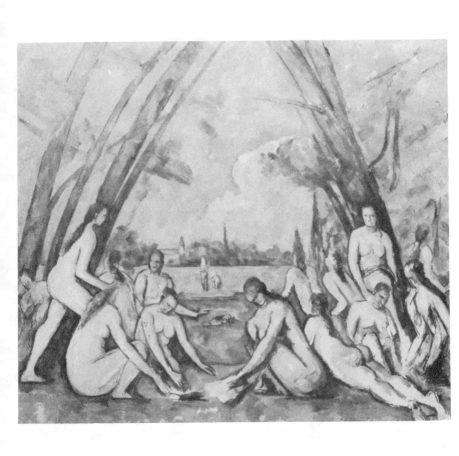

32. CÉZANNE: *Great Bathers*